Spike Milligan

DIARY 2021

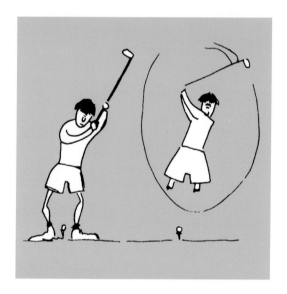

Spike Milligan was born in 1918 in India. Perhaps best known as the creator and writer of the *Goon Show*, Milligan's prolific career received accolades for his work as a comedian, musician, poet and playwright.

First published in 2020

20 22 24 23 21

1 3 5 7 9 10 8 6 4 2

Created and produced by
FLAME TREE PUBLISHING
6 Melbray Mews,
London SW6 3NS, UK
Tel: +44 (0) 20 7751 9650
Fax: +44 (0) 20 7751 9651
info@flametreepublishing.com
www.flametreepublishing.com

ISBN: 978-1-83964-102-2

All images by Spike Milligan (1918–2002)
© Spike Milligan Productions Ltd.

Front cover: Golf
Back cover: Toucans

A CIP record for this book is available from the British Library upon request.

Every attempt has been made to ensure the accuracy of the date information at the time of going
to press, and the publishers cannot accept responsibility for any errors. Some public holidays are subject
to change by Royal or State proclamation. At the time of publication, accurate information was unavailable
for all religious celebrations in 2021. All Jewish and Islamic holidays begin at sunset on the previous
day and end at sunset on the date shown. Moon phases are based on GMT.

Every effort has been made to contact all copyright holders. The publishers
would be pleased to hear if any oversights or omissions have occurred.

Created and Published in UK. Printed in China.

New Moon

First Quarter

Full Moon

Last Quarter

MIX
Paper from
responsible sources
FSC® C005748
www.fsc.org

2020

JANUARY
M	T	W	T	F	S	S
		1	2	3	4	5
6	7	8	9	10	11	12
13	14	15	16	17	18	19
20	21	22	23	24	25	26
27	28	29	30	31		

FEBRUARY
M	T	W	T	F	S	S
					1	2
3	4	5	6	7	8	9
10	11	12	13	14	15	16
17	18	19	20	21	22	23
24	25	26	27	28	29	

MARCH
M	T	W	T	F	S	S
						1
2	3	4	5	6	7	8
9	10	11	12	13	14	15
16	17	18	19	20	21	22
23	24	25	26	27	28	29
30	31					

APRIL
M	T	W	T	F	S	S
		1	2	3	4	5
6	7	8	9	10	11	12
13	14	15	16	17	18	19
20	21	22	23	24	25	26
27	28	29	30			

MAY
M	T	W	T	F	S	S
				1	2	3
4	5	6	7	8	9	10
11	12	13	14	15	16	17
18	19	20	21	22	23	24
25	26	27	28	29	30	31

JUNE
M	T	W	T	F	S	S
1	2	3	4	5	6	7
8	9	10	11	12	13	14
15	16	17	18	19	20	21
22	23	24	25	26	27	28
29	30					

JULY
M	T	W	T	F	S	S
		1	2	3	4	5
6	7	8	9	10	11	12
13	14	15	16	17	18	19
20	21	22	23	24	25	26
27	28	29	30	31		

AUGUST
M	T	W	T	F	S	S
					1	2
3	4	5	6	7	8	9
10	11	12	13	14	15	16
17	18	19	20	21	22	23
24	25	26	27	28	29	30
31						

SEPTEMBER
M	T	W	T	F	S	S
	1	2	3	4	5	6
7	8	9	10	11	12	13
14	15	16	17	18	19	20
21	22	23	24	25	26	27
28	29	30				

OCTOBER
M	T	W	T	F	S	S
			1	2	3	4
5	6	7	8	9	10	11
12	13	14	15	16	17	18
19	20	21	22	23	24	25
26	27	28	29	30	31	

NOVEMBER
M	T	W	T	F	S	S
						1
2	3	4	5	6	7	8
9	10	11	12	13	14	15
16	17	18	19	20	21	22
23	24	25	26	27	28	29
30						

DECEMBER
M	T	W	T	F	S	S
	1	2	3	4	5	6
7	8	9	10	11	12	13
14	15	16	17	18	19	20
21	22	23	24	25	26	27
28	29	30	31			

2021

JANUARY
M	T	W	T	F	S	S
				1	2	3
4	5	6	7	8	9	10
11	12	13	14	15	16	17
18	19	20	21	22	23	24
25	26	27	28	29	30	31

FEBRUARY
M	T	W	T	F	S	S
1	2	3	4	5	6	7
8	9	10	11	12	13	14
15	16	17	18	19	20	21
22	23	24	25	26	27	28

MARCH
M	T	W	T	F	S	S
1	2	3	4	5	6	7
8	9	10	11	12	13	14
15	16	17	18	19	20	21
22	23	24	25	26	27	28
29	30	31				

APRIL
M	T	W	T	F	S	S
			1	2	3	4
5	6	7	8	9	10	11
12	13	14	15	16	17	18
19	20	21	22	23	24	25
26	27	28	29	30		

MAY
M	T	W	T	F	S	S
					1	2
3	4	5	6	7	8	9
10	11	12	13	14	15	16
17	18	19	20	21	22	23
24	25	26	27	28	29	30
31						

JUNE
M	T	W	T	F	S	S
	1	2	3	4	5	6
7	8	9	10	11	12	13
14	15	16	17	18	19	20
21	22	23	24	25	26	27
28	29	30				

JULY
M	T	W	T	F	S	S
			1	2	3	4
5	6	7	8	9	10	11
12	13	14	15	16	17	18
19	20	21	22	23	24	25
26	27	28	29	30	31	

AUGUST
M	T	W	T	F	S	S
						1
2	3	4	5	6	7	8
9	10	11	12	13	14	15
16	17	18	19	20	21	22
23	24	25	26	27	28	29
30	31					

SEPTEMBER
M	T	W	T	F	S	S
		1	2	3	4	5
6	7	8	9	10	11	12
13	14	15	16	17	18	19
20	21	22	23	24	25	26
27	28	29	30			

OCTOBER
M	T	W	T	F	S	S
				1	2	3
4	5	6	7	8	9	10
11	12	13	14	15	16	17
18	19	20	21	22	23	24
25	26	27	28	29	30	31

NOVEMBER
M	T	W	T	F	S	S
1	2	3	4	5	6	7
8	9	10	11	12	13	14
15	16	17	18	19	20	21
22	23	24	25	26	27	28
29	30					

DECEMBER
M	T	W	T	F	S	S
		1	2	3	4	5
6	7	8	9	10	11	12
13	14	15	16	17	18	19
20	21	22	23	24	25	26
27	28	29	30	31		

2022

JANUARY
M	T	W	T	F	S	S
					1	2
3	4	5	6	7	8	9
10	11	12	13	14	15	16
17	18	19	20	21	22	23
24	25	26	27	28	29	30
31						

FEBRUARY
M	T	W	T	F	S	S
	1	2	3	4	5	6
7	8	9	10	11	12	13
14	15	16	17	18	19	20
21	22	23	24	25	26	27
28						

MARCH
M	T	W	T	F	S	S
	1	2	3	4	5	6
7	8	9	10	11	12	13
14	15	16	17	18	19	20
21	22	23	24	25	26	27
28	29	30	31			

APRIL
M	T	W	T	F	S	S
				1	2	3
4	5	6	7	8	9	10
11	12	13	14	15	16	17
18	19	20	21	22	23	24
25	26	27	28	29	30	

MAY
M	T	W	T	F	S	S
						1
2	3	4	5	6	7	8
9	10	11	12	13	14	15
16	17	18	19	20	21	22
23	24	25	26	27	28	29
30	31					

JUNE
M	T	W	T	F	S	S
		1	2	3	4	5
6	7	8	9	10	11	12
13	14	15	16	17	18	19
20	21	22	23	24	25	26
27	28	29	30			

JULY
M	T	W	T	F	S	S
				1	2	3
4	5	6	7	8	9	10
11	12	13	14	15	16	17
18	19	20	21	22	23	24
25	26	27	28	29	30	31

AUGUST
M	T	W	T	F	S	S
1	2	3	4	5	6	7
8	9	10	11	12	13	14
15	16	17	18	19	20	21
22	23	24	25	26	27	28
29	30	31				

SEPTEMBER
M	T	W	T	F	S	S
			1	2	3	4
5	6	7	8	9	10	11
12	13	14	15	16	17	18
19	20	21	22	23	24	25
26	27	28	29	30		

OCTOBER
M	T	W	T	F	S	S
					1	2
3	4	5	6	7	8	9
10	11	12	13	14	15	16
17	18	19	20	21	22	23
24	25	26	27	28	29	30
31						

NOVEMBER
M	T	W	T	F	S	S
	1	2	3	4	5	6
7	8	9	10	11	12	13
14	15	16	17	18	19	20
21	22	23	24	25	26	27
28	29	30				

DECEMBER
M	T	W	T	F	S	S
			1	2	3	4
5	6	7	8	9	10	11
12	13	14	15	16	17	18
19	20	21	22	23	24	25
26	27	28	29	30	31	

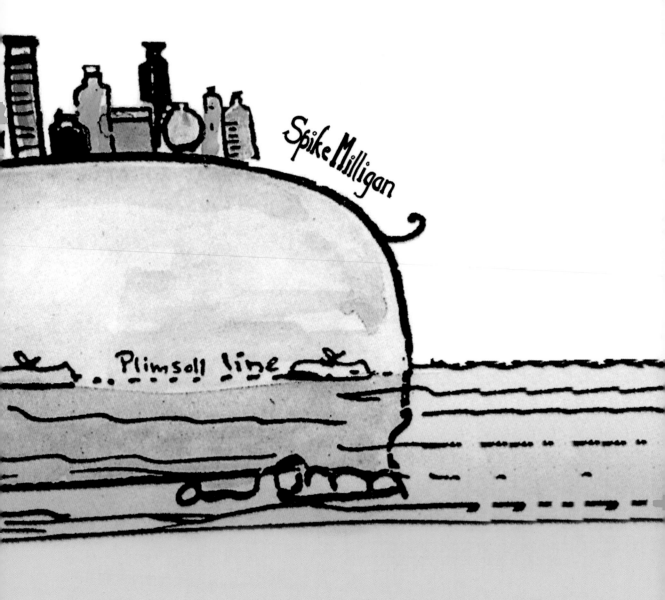

Spike Milligan

Plimsoll line

A Hippochondriac

Personal Information

Name

Address

Telephone

Mobile

Fax

Email

Bank Telephone

Credit Card Telephone

National Insurance No.

Passport No.

Driving Licence No.

AA or RAC Membership No.

In Case of Emergency

Contact

Telephone

Doctor

Known Allergies

Spike Milligan

Notes

Spike Milligan

December 2020/January

28 Monday

29 Tuesday

30 Wednesday ○

31 Thursday

New Year's Eve

1 Friday

New Year's Day

2 Saturday

Public Holiday (Scot, NZ)

3 Sunday

Spike Milligan

4 Monday

Public Holiday (Scot, NZ) (observed)

5 Tuesday

6 Wednesday

Epiphany
Three Kings' Day

7 Thursday

8 Friday

9 Saturday

10 Sunday

Spike Milligan

'It's the little things that count.'

11 Monday

Coming of Age Day (Japan)

12 Tuesday

● 13 Wednesday

14 Thursday

Makar Sankranti

15 Friday

16 Saturday

17 Sunday

It's The Little Things
© Spike Milligan Productions Ltd

Spike Milligan

January

18 Monday

Martin Luther King Jr Day (USA)

19 Tuesday

Birthday of Guru Gobind Singh

20 Wednesday

21 Thursday

22 Friday

23 Saturday

24 Sunday

They Told Me
© Spike Milligan Productions Ltd

January

25 Monday

26 Tuesday

Burns Night (Scot)

27 Wednesday

Australia Day

28 Thursday ○

29 Friday

30 Saturday

31 Sunday

Spike Milligan

February

1 Monday

2 Tuesday

Groundhog Day (USA, Canada)

3 Wednesday

4 Thursday

5 Friday

6 Saturday

Waitangi Day (NZ)

7 Sunday

Spike Milligan

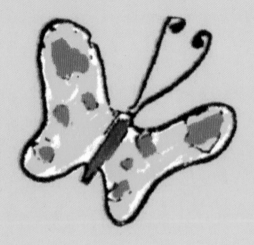

Butterfly butterfly

Making colours in the sky

Red white and blue upon your wings

You are the loveliest of things.

Spike Milligan

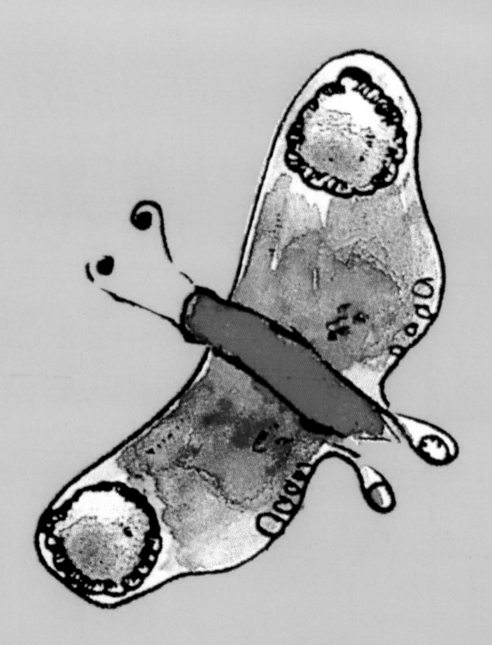

"It was a perfect marriage.
She didn't want to
and he couldn't."

Spike Milligan

February

8 Monday

Waitangi Day (NZ) (observed)

9 Tuesday

10 Wednesday

● 11 Thursday

National Foundation Day (Japan)

12 Friday

Chinese New Year
Year of the Ox

13 Saturday

14 Sunday

St Valentine's Day

Perfect Marriage
© Spike Milligan Productions Ltd

Spike Milligan

February

15 Monday

President's Day (USA)

16 Tuesday

Shrove Tuesday
Pancake Day
Vasant Panchami

17 Wednesday

Ash Wednesday

18 Thursday

19 Friday ◑

20 Saturday

21 Sunday

First Sunday of Lent

People who live in glass houses
should pull the blinds
when removing their trousers

Spike Milligan

February

22 Monday

23 Tuesday

24 Wednesday

The Emperor's Birthday (Japan)

25 Thursday

26 Friday

27 Saturday

Purim

28 Sunday

Spike Milligan

March

1 Monday

St David's Day (Wales)

2 Tuesday

3 Wednesday

4 Thursday

5 Friday

 6 Saturday

7 Sunday

Spike Milligan

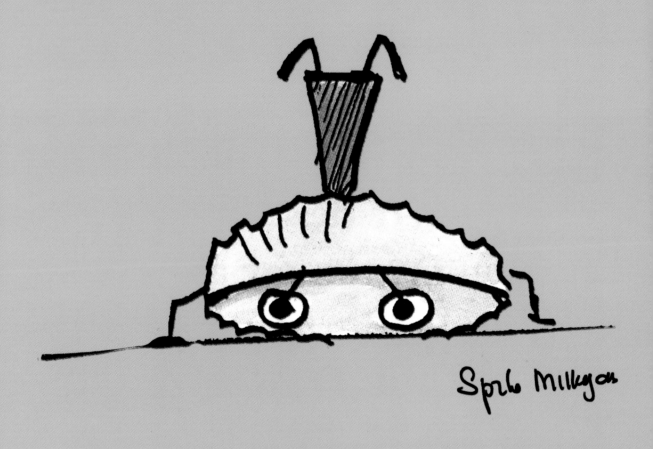

The Wiggle-Woggle said,
'When I'm standing on my head
I can see the coast of China
And it's very, very Red.'

March

8 Monday

Commonwealth Day
International Women's Day

9 Tuesday

10 Wednesday

11 Thursday

Maha Shivaratri

12 Friday

13 Saturday

14 Sunday

Mother's Day (UK, Éire)

The Wiggle-Woggle
© Spike Milligan Productions Ltd

March

15 Monday

16 Tuesday

17 Wednesday

St Patrick's Day (Éire, N. Ireland)

18 Thursday

19 Friday

20 Saturday

Spring Equinox

21 Sunday

Human Rights Day (SA)

Site for Sore Eyes
© Spike Milligan Productions Ltd

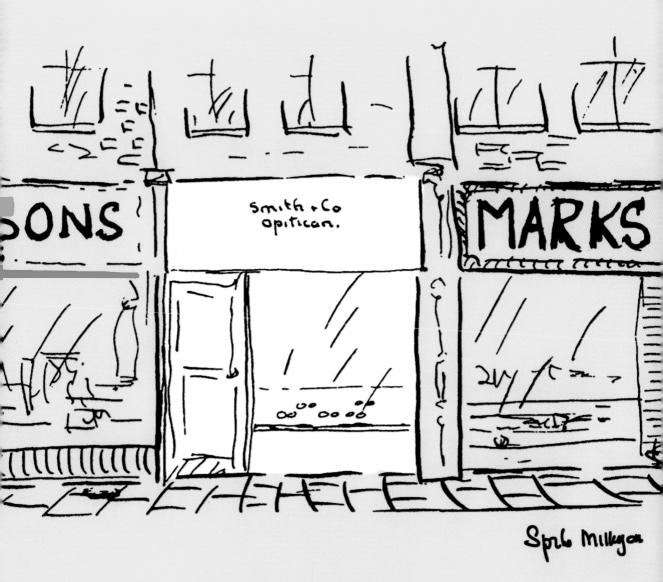

Site for Sore Eyes

March

22 Monday

23 Tuesday

24 Wednesday

25 Thursday

26 Friday

27 Saturday

28 Sunday

○

Palm Sunday
First Day of Passover (Pesach)
British Summer Time begins

Spike Milligan

March/April

29 Monday

Holi
Hola Mohalla

30 Tuesday

31 Wednesday

1 Thursday

Maundy Thursday

2 Friday

Good Friday

3 Saturday

◑ 4 Sunday

Easter Sunday
Last Day of Passover (Pesach)

Spike Milligan

Don't change horses
in midstream,
supposing the one you are on
can't swim

Spike Milligan

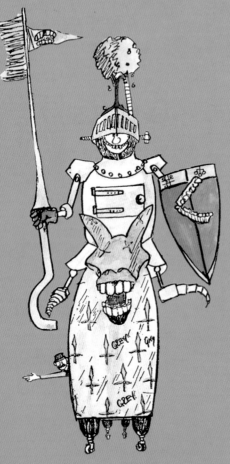

April

5 Monday

Easter Monday
Family Day (SA)

6 Tuesday

7 Wednesday

8 Thursday

9 Friday

10 Saturday

11 Sunday

Don't Change Horse
© Spike Milligan Productions Ltd

12 Monday ●

13 Tuesday

Ramadan begins
Ramayana Week begins
Hindi New Year

14 Wednesday

Vaisakhi

15 Thursday

16 Friday

17 Saturday

18 Sunday

FLUFFY BUM THE
CAT

Spike Milligan

April

19 Monday

20 Tuesday ◑

21 Wednesday

Ramanavami

22 Thursday

23 Friday

St George's Day (England)

24 Saturday

25 Sunday

Anzac Day (AU, NZ)

Spike Milligan

April/May

26 Monday

Anzac Day (AU, NZ) (observed)

○ 27 Tuesday

Hanuman Jayanti
Freedom Day (SA)

28 Wednesday

29 Thursday

Shōwa Day (Japan)

30 Friday

1 Saturday

Workers' Day (SA)

2 Sunday

Spike Milligan

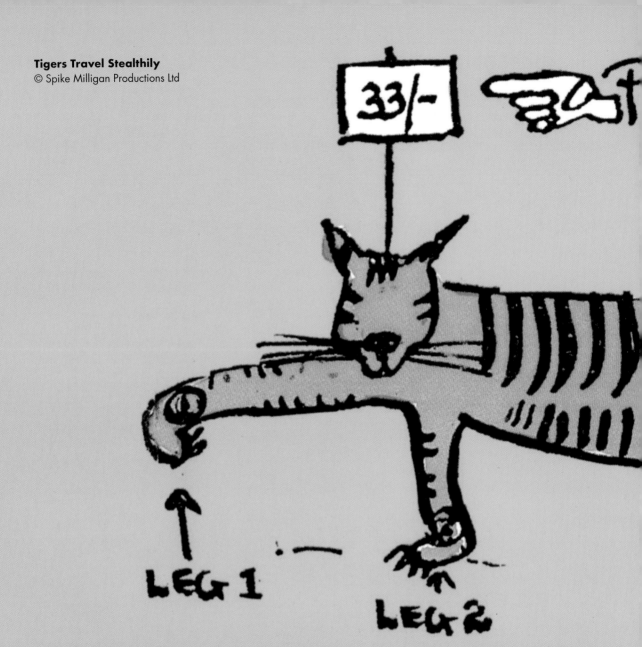

Tigers travel stealthily
Using, first, legs one and three.
They alternate with two and four;
And, after that, there are no more.

on Tyers head.

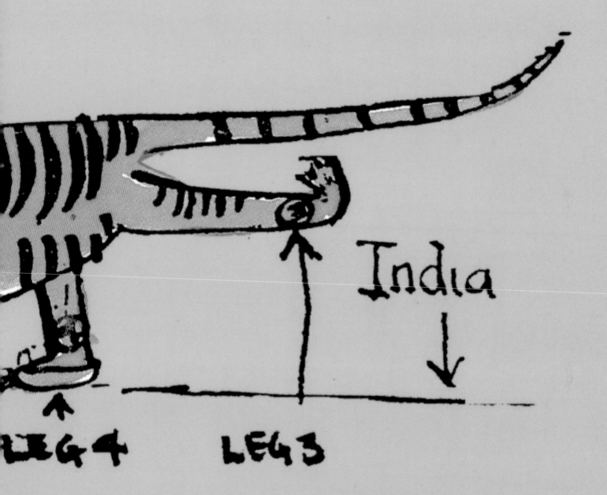

India

LEG 4 LEG 3

Spike Milligan

3 Monday

May Bank Holiday (UK, Éire)
Constitution Memorial Day (Japan)

4 Tuesday

Greenery Day (Japan)

5 Wednesday

Children's Day (Japan)

6 Thursday

7 Friday

8 Saturday

9 Sunday

Mother's Day (USA, Canada, AU, NZ, SA, Japan)

He's Forgotten
© Spike Milligan Productions Ltd

Spike Milligan

May

10 Monday

11 Tuesday ●

12 Wednesday

Ramadan ends

13 Thursday

Eid al-Fitr
Ascension Day

14 Friday

15 Saturday

16 Sunday

Golf
© Spike Milligan Productions Ltd

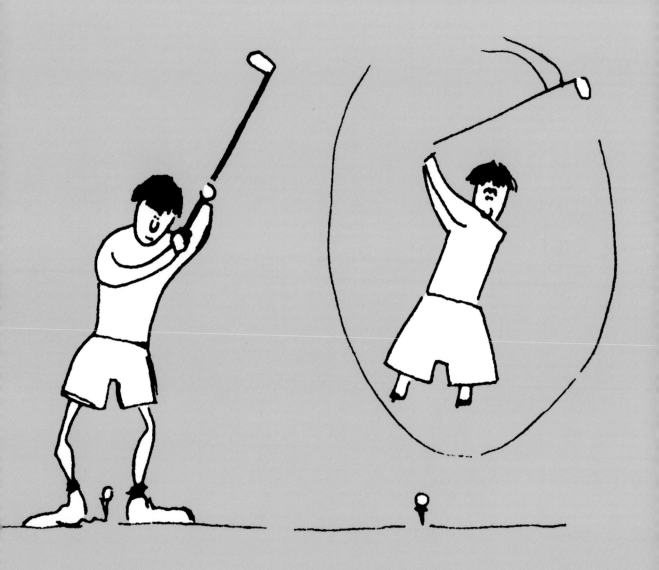

Spike Milligan

May

17 Monday

Shavuot begins

18 Tuesday

Shavuot ends

19 Wednesday

20 Thursday

21 Friday

22 Saturday

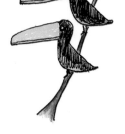

23 Sunday

Whit Sunday (Pentecost)

Spike Milligan

May

24 Monday

Victoria Day (Canada)

25 Tuesday

○ 26 Wednesday

27 Thursday

28 Friday

29 Saturday

30 Sunday

Trinity Sunday

Spike Milligan

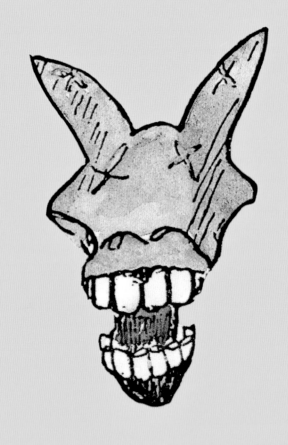

Apéritif: French for a set of dentures

Spike Milligan

31 Monday

Spring Bank Holiday (UK)
Memorial Day (USA)

1 Tuesday

2 Wednesday

Coronation Day

3 Thursday

Corpus Christi

4 Friday

5 Saturday

6 Sunday

Apéritif
© Spike Milligan Productions Ltd

Spike Milligan

June

7 Monday

June Bank Holiday (Éire)

8 Tuesday

9 Wednesday

10 Thursday ●

11 Friday

12 Saturday

The Queen's Official Birthday (UK)

13 Sunday

Spike Milligan

Toucans
© Spike Milligan Productions Ltd

Onecan # Toucans

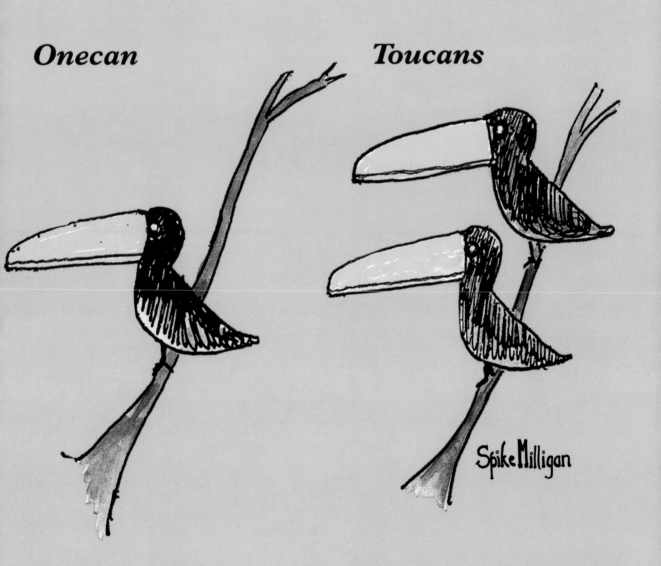

Spike Milligan

June

14 Monday

Dragon Boat Festival

15 Tuesday

16 Wednesday

Youth Day (SA)
Martyrdom of Guru Arjan Dev

17 Thursday

18 Friday ◗

19 Saturday

20 Sunday

Father's Day (UK, Éire, USA, Canada, SA, Japan)

Spike Milligan

June

21 Monday

Summer Solstice

22 Tuesday

Windrush Day (UK)

23 Wednesday

24 Thursday

25 Friday

26 Saturday

27 Sunday

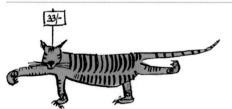

Spike Milligan

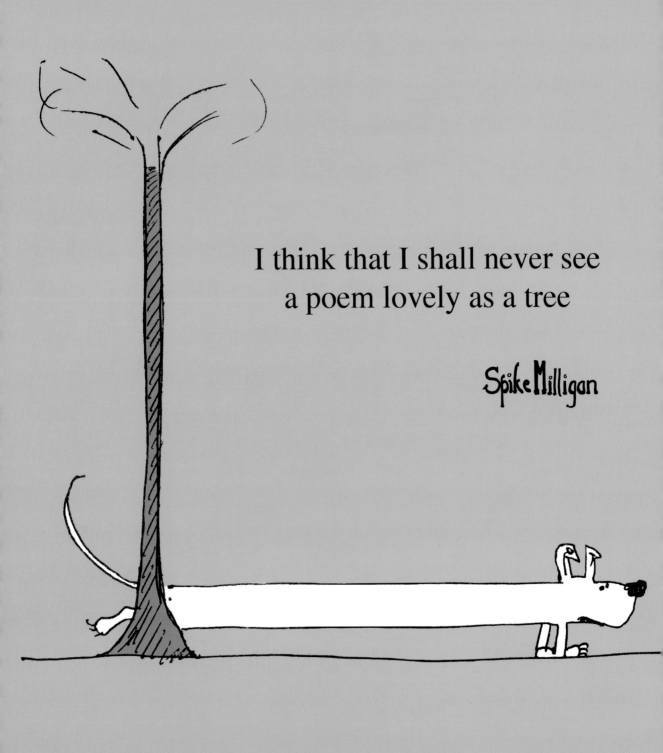

I think that I shall never see
a poem lovely as a tree

Spike Milligan

June/July

28 Monday

29 Tuesday

30 Wednesday

◑ 1 Thursday

Canada Day

2 Friday

3 Saturday

4 Sunday

Independence Day (USA)

I Think That I Shall Never See
© Spike Milligan Productions Ltd

Spike Milligan

July

5 Monday

6 Tuesday

7 Wednesday

8 Thursday

9 Friday

10 Saturday ●

11 Sunday

Spike Milligan

Cliffhanger
© Spike Milligan Productions Ltd

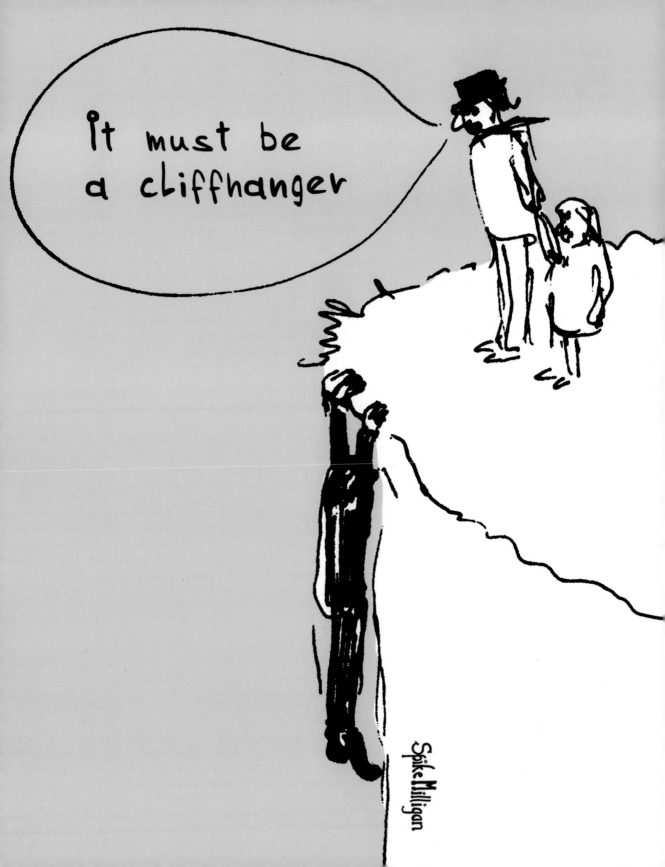

July

12 Monday

13 Tuesday

14 Wednesday

15 Thursday

16 Friday

17 Saturday ◑

18 Sunday

Tish'a B'Av

Spike Milligan

19 Monday

Marine Day (Japan)

20 Tuesday

Eid al-Adha

21 Wednesday

22 Thursday

23 Friday

○ 24 Saturday

25 Sunday

Spike Milligan

"Chopsticks are one of the reasons the Chinese never invented custard"

Spike Milligan

July/August

26 Monday

27 Tuesday

28 Wednesday

29 Thursday

30 Friday

31 Saturday

1 Sunday

Chopsticks
© Spike Milligan Productions Ltd

Spike Milligan

August

2 Monday

Summer Bank Holiday (Scot)
August Bank Holiday (Éire)

3 Tuesday

4 Wednesday

5 Thursday

6 Friday

7 Saturday

8 Sunday

●

Spike Milligan

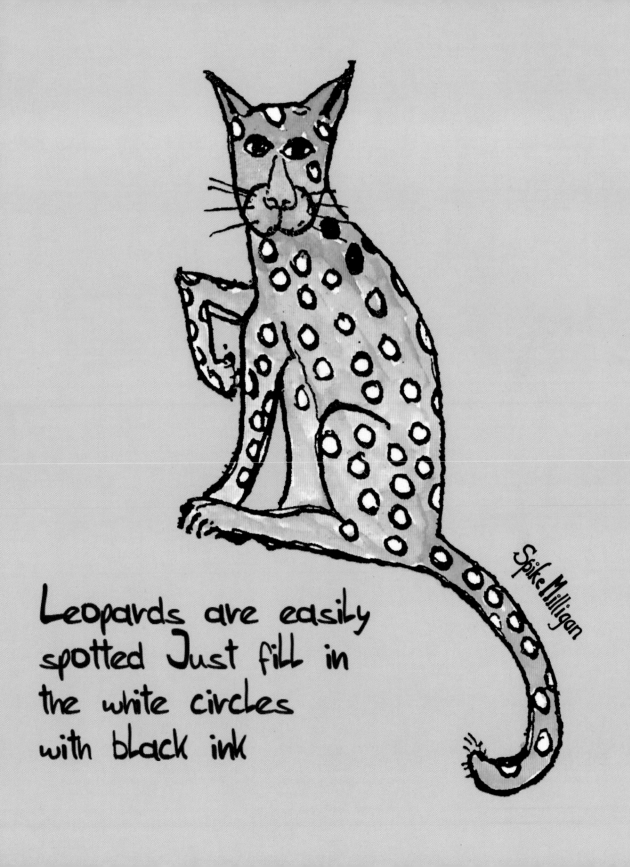

Leopards are easily
spotted Just fill in
the white circles
with black ink

Spike Milligan

9 Monday

National Women's Day (SA)
Islamic New Year
Muḥarram

10 Tuesday

11 Wednesday

Mountain Day (Japan)

12 Thursday

13 Friday

14 Saturday

15 Sunday ◖

August

16 Monday

17 Tuesday

18 Wednesday

19 Thursday

20 Friday

21 Saturday

○ 22 Sunday

Raksha Bandhan

Spike Milligan

Things that go 'bump!' in the night,
Should not really give one a fright.
It's the hole in each ear
That lets in the fear,
That, and the absence of light!

Spike Milligan

August

23 Monday

24 Tuesday

25 Wednesday

26 Thursday

27 Friday

28 Saturday

29 Sunday

Spike Milligan

August/September

30 Monday ◑

Summer Bank Holiday (UK except Scot)
Krishna Janmashthami

31 Tuesday

1 Wednesday

2 Thursday

3 Friday

4 Saturday

5 Sunday

Father's Day (AU, NZ)

Said the General
© Spike Milligan Productions Ltd

Spike Milligan

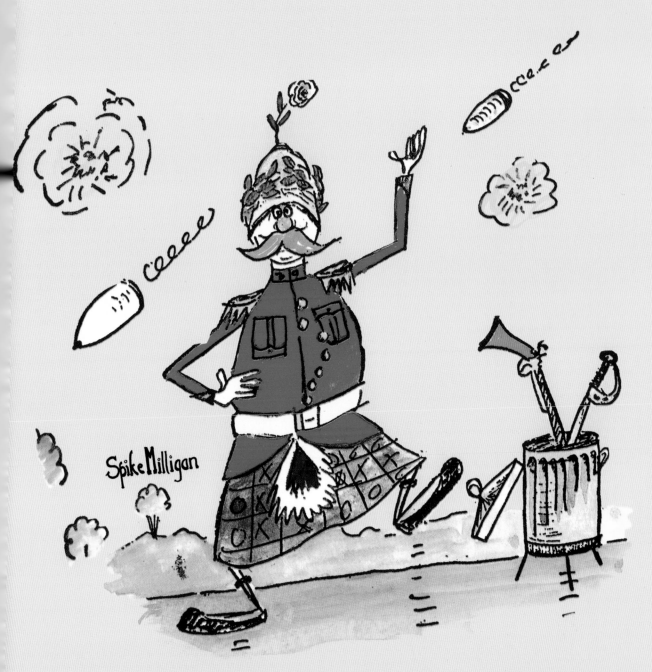

Said the General of the Army, 'I think the war is barmy'
So he threw away his gun: Now he's having much more fun.

6 Monday

Labour Day (Canada, USA)

7 Tuesday

●

Jewish New Year (Rosh Hashanah) begins

8 Wednesday

Jewish New Year (Rosh Hashanah) ends

9 Thursday

10 Friday

Ganesh Chaturthi

11 Saturday

12 Sunday

Grandparents Day (USA, Canada)

September

13 Monday

14 Tuesday

15 Wednesday

16 Thursday

Day of Atonement (Yom Kippur)

17 Friday

18 Saturday

19 Sunday

Spike Milligan

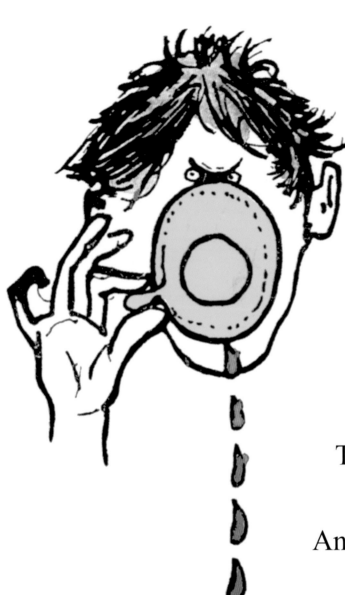

There's many a slip
Twix cup and lip,
And the sound it makes
Is drip drip drip.

Spike Milligan

September

○ 20 Monday

Respect for the Aged Day (Japan)
 21 Tuesday

International Day of Peace
First Day of Sukkot (Feast of Tabernacles)
Pitr-paksha begins
 22 Wednesday

Autumn Equinox
 23 Thursday

 24 Friday

Heritage Day (SA)
 25 Saturday

 26 Sunday

There's Many a Slip
© Spike Milligan Productions Ltd

Spike Milligan

September/October

27 Monday

28 Tuesday

Shemini Atzeret

29 Wednesday

Simchat Torah

30 Thursday

1 Friday

2 Saturday

3 Sunday

Spike Milligan

Gammon Rasher
© Spike Milligan Productions Ltd

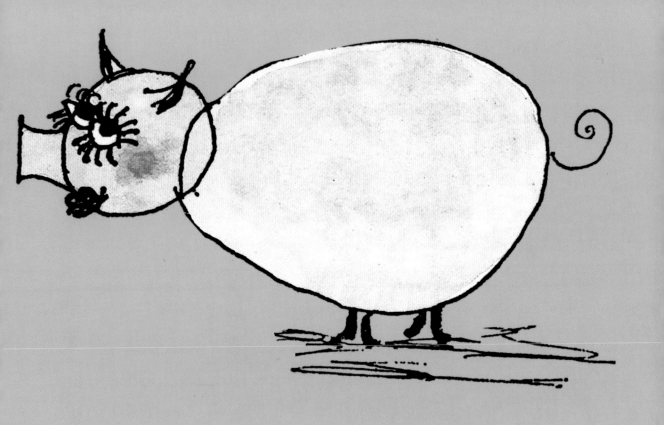

A very rash young lady pig
(They say she was a smasher)
Suddenly ran
Under a van -
Now she's a gammon rasher

October

4 Monday

5 Tuesday

6 Wednesday ●

Pitr-paksha ends

7 Thursday

Navaratri begins

8 Friday

9 Saturday

10 Sunday

Spike Milligan

October

11 Monday

Thanksgiving Day (Canada)
Columbus Day (USA)
Indigenous Peoples' Day (USA)
Health and Sports Day (Japan)

12 Tuesday

◑ 13 Wednesday

14 Thursday

Navaratri ends

15 Friday

Dussehra

16 Saturday

17 Sunday

Spike Milligan

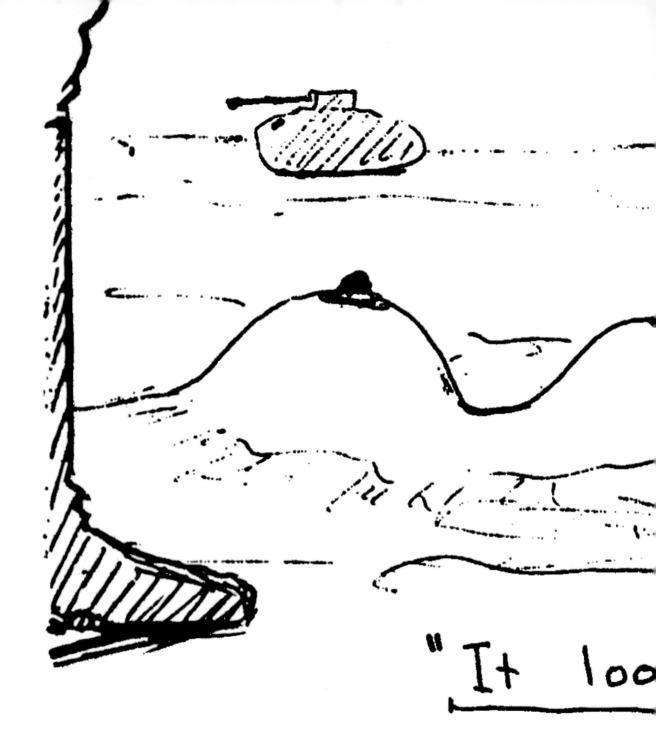

"It loo

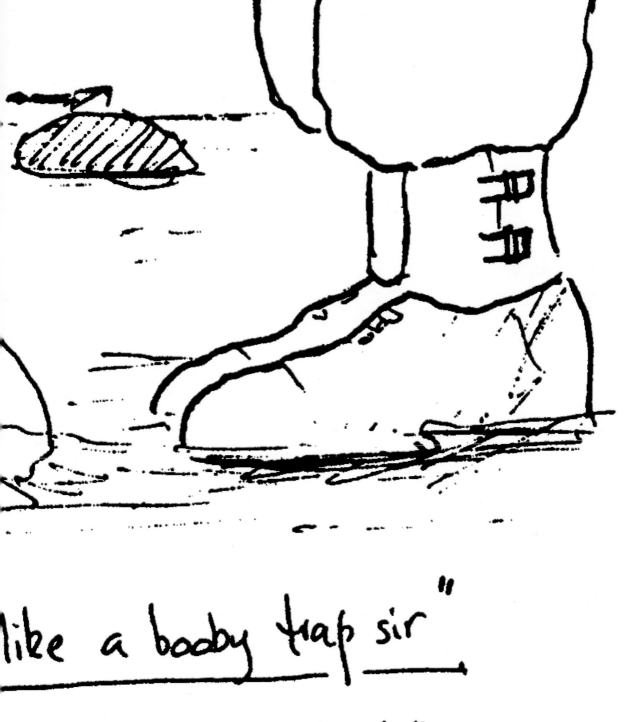

like a booby trap sir"

A Spike Milligan
World War II Joke

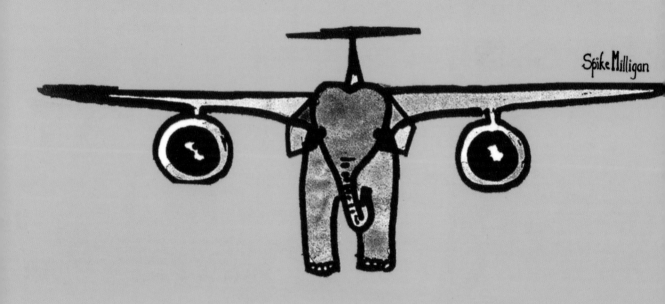

jumbo-jet

October

18 Monday

19 Tuesday

Birthday of the Islamic Prophet Muhammad

○

20 Wednesday

21 Thursday

22 Friday

23 Saturday

24 Sunday

Spike Milligan

25 Monday

26 Tuesday

27 Wednesday

28 Thursday

29 Friday

30 Saturday

31 Sunday

Halloween
British Summer Time ends

Spike Milligan

November

1 Monday

All Saints' Day

2 Tuesday

3 Wednesday

Culture Day (Japan)

● 4 Thursday

Diwali
Bandi Chhor Divas

5 Friday

Vikram New Year

6 Saturday

7 Sunday

Spike Milligan

8 Monday

9 Tuesday

It must be a cliffhanger

10 Wednesday

11 Thursday

Remembrance Day
(Armistice Day)
Veterans' Day (USA)

12 Friday

13 Saturday

14 Sunday

Remembrance Sunday

A Man Was Under A Bolt of Thunder
© Spike Milligan Productions Ltd

Spike Milligan

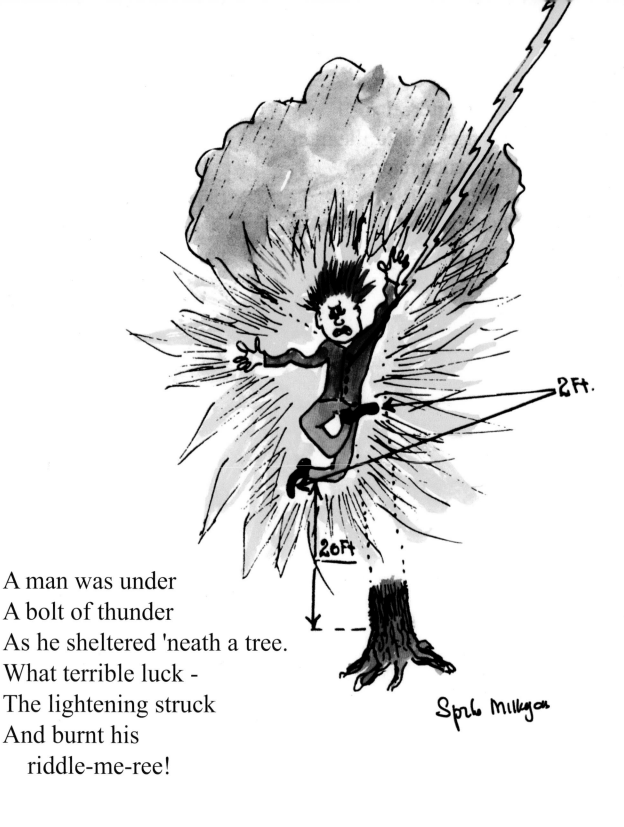

A man was under
A bolt of thunder
As he sheltered 'neath a tree.
What terrible luck -
The lightening struck
And burnt his
 riddle-me-ree!

November

15 Monday

16 Tuesday

17 Wednesday

18 Thursday

Birthday of Guru Nanak

19 Friday ○

20 Saturday

21 Sunday

Spike Milligan

November

22 Monday

23 Tuesday

Labour Thanksgiving Day (Japan)

24 Wednesday

Martyrdom of Guru Tegh Bahadur

25 Thursday

Thanksgiving Day (USA)

26 Friday

27 Saturday

28 Sunday

Advent Sunday

Spike Milligan

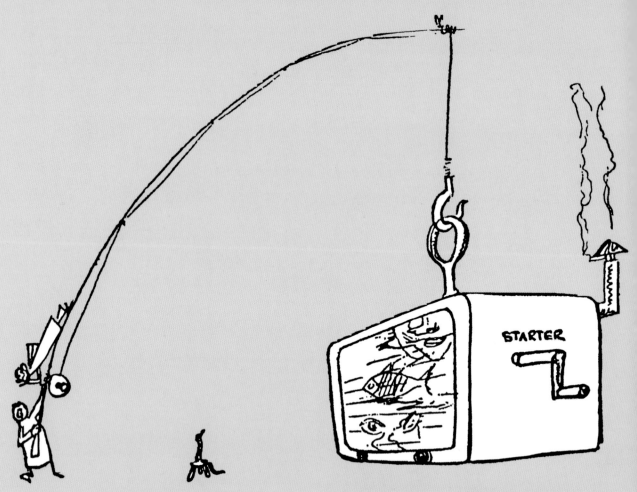

Today I saw a little worm
Wriggling on his belly.
Perhaps he'd like to come inside
And see what's on the telly.

Spike Milligan

November/December

29 Monday

Hanukkah begins

30 Tuesday

St Andrew's Day (Scot)

1 Wednesday

2 Thursday

3 Friday

● 4 Saturday

5 Sunday

Today I Saw A Little Worm
© Spike Milligan Productions Ltd

Spike Milligan

December

6 Monday

Hanukkah ends

7 Tuesday

8 Wednesday

Bodhi Day

9 Thursday

10 Friday

11 Saturday ◑

12 Sunday

Spike Milligan

Chimp-Chimp-Chimpanzee
© Spike Milligan Productions Ltd

Chimp-chimp-chimpanzee
Some look like you and some like me
Mr Darwin clearly stated
That some time back we are related

Spike Milligan

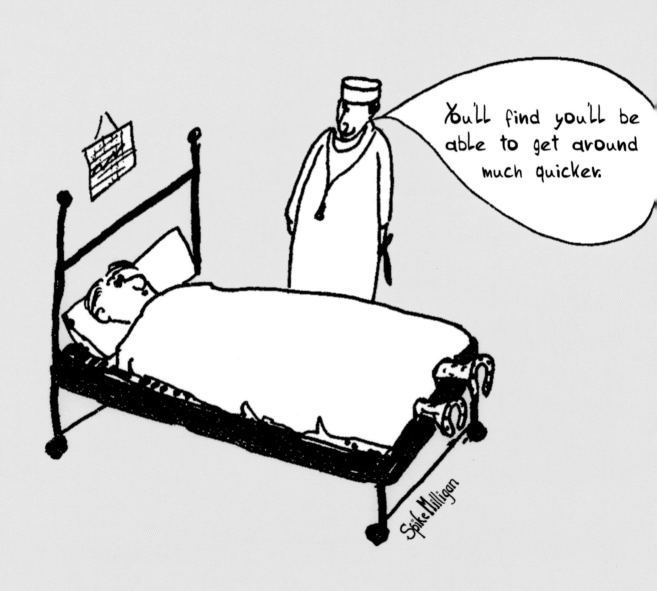

December

13 Monday

14 Tuesday

15 Wednesday

16 Thursday

Day of Reconciliation (SA)

17 Friday

18 Saturday

○ 19 Sunday

You'll Find You'll Be Able to Get Around

Spike Milligan

December

20 Monday

21 Tuesday

Winter Solstice

22 Wednesday

23 Thursday

24 Friday

Christmas Eve

25 Saturday

Christmas Day

26 Sunday

Boxing Day
St Stephen's Day (Éire)
Day of Goodwill (SA)

Spike Milligan

Merry Christmas
© Spike Milligan Productions Ltd

MERRY CHRISTMAS

Spike Milligan

Better late than never:
Rubbish, if you never show up,
you'll never be late

Spike Milligan

December/January 2022

◑ 27 Monday

Christmas Day (observed)
Day of Goodwill (SA) (observed)

28 Tuesday

Boxing Day (observed)
St Stephen's Day (Éire) (observed)

29 Wednesday

30 Thursday

31 Friday

New Year's Eve

1 Saturday

New Year's Day

● 2 Sunday

Better Late Than Never
© Spike Milligan Productions Ltd

Spike Milligan

Esquimau, esquimau,
Up to everywhere in snau!
On your little sledge you gau,
Leaping from ice flau to flau
Now I knau, I knau, I knau
Why progress in the snau is slau!

Esquimau

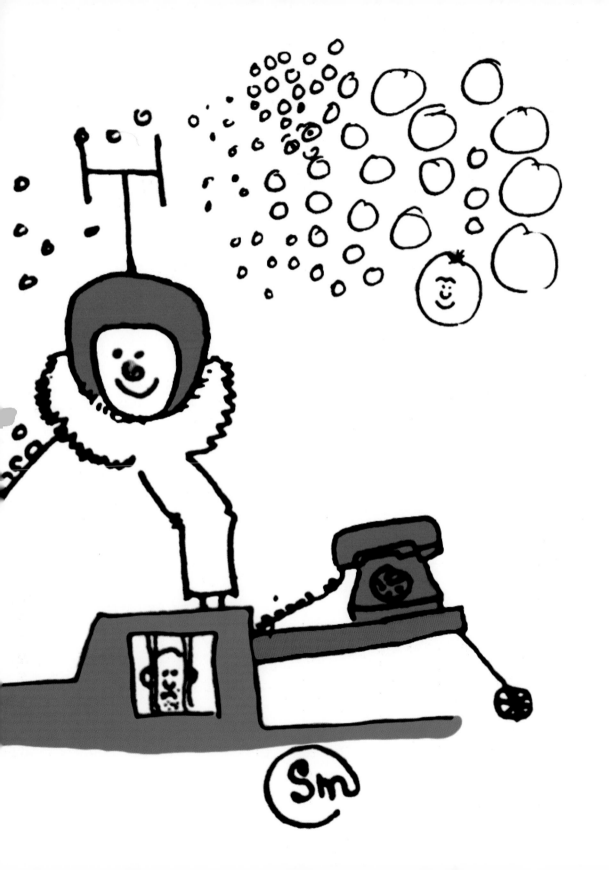

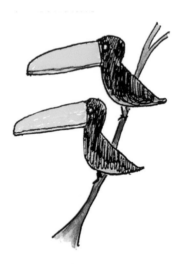

Toucans
© Spike Milligan Productions Ltd

Spike Milligan